DRAWING MADE FUN

DOGS

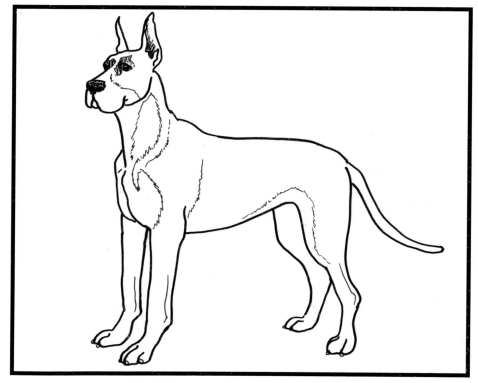

Robin Lee Makowski

Rourke
Publishing LLC
Vero Beach, Florida 32964

www.rourkepublishing.com

All illustrations Robin Lee Makowski.

Editor: Frank Sloan

Cover design by Nicola Stratford

Library of Congress Cataloging-in-Publication Data

Makowski, Robin Lee.
 Dogs / written and illustrated by Robin Lee Makowski.
 p. cm. -- (Drawing made fun)
 ISBN 1-59515-469-8 (hardcover)
 1. Dogs in art--Juvenile literature. 2. Drawing--Technique--Juvenile
literature. I. Title.
 NC783.8.D64M354 2006
 743.6'9772--dc22
 2005010721

Printed in the USA

CG/CG

Rourke Publishing
1-800-394-7055
www.rourkepublishing.com
sales@rourkepublishing.com
Post Office Box 3328, Vero Beach, FL 32964

INTRODUCTION

Drawing is a skill that is fun and useful, and something everyone wants to learn how to do better.

The step-by-step instructions in this book will help you first to see what you want to draw. Then you can place the parts correctly so your finished drawing looks the way you want it to. Of course, the only way to perfect your drawing skills is to practice, practice, practice!

If the drawing doesn't look right the first time, draw it again. It can be frustrating if the finished drawing doesn't look the way you wanted it to and you don't know how to fix it.

Follow the instructions and have fun learning how to draw your favorite dogs!

MATERIALS

The two most common problems with drawing are not seeing how the parts of the object line up and using the wrong materials. The first problem will be solved with practice. The second problem is much easier to fix. You'll have a lot more fun and success with your drawings if you're not fighting with hard pencils, dry erasers, and thin paper.

These materials are available almost anywhere and will make your practice much easier:

Best to Use
Soft Pencils (#2B or softer)
Thick and Thin Drawing Pens
Soft White Eraser or Kneaded Eraser
Pencil Sharpener
Drawing Paper Tablet
Tracing Paper
Wax-Free Graphite Paper (helpful but not necessary)
Crayons or Colored Pencils or Colored Markers

More Difficult to Use
Typing or Computer Paper
Hard or Pink Erasers
Hard Pencils (if the pencil will mark your hand, it's soft enough)

HOW TO START

The Shapes of Things

Everything you draw in this book will start with larger geometric shapes to get the proportions and to get everything lined up correctly. Then the details will emerge from there. One of the biggest mistakes made when drawing is starting with the outline. By the time the outline is finished, the proportions are way off.

You'll use both standard geometric shapes and free-form shapes to start:

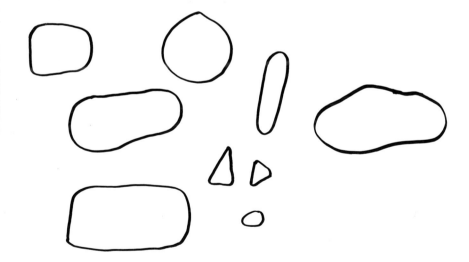

Laying Down the Lines

You can do your preliminary drawing—and make your mistakes—on tracing paper and then transfer it to the drawing paper. If you draw directly on the drawing paper, you can keep your drawing clean by putting a piece of scrap paper under your hand so you don't smear the pencil as you work.

When you start your drawing, use light lines so you can erase. Your preliminary shapes do not need to be perfect—they are only guidelines for your final drawing. Make sure everything lines up!

Tracing paper will take a lot of erasing. To transfer your preliminary drawing, use wax-free graphite paper between the tracing paper and drawing paper. Be sure the graphite side is down!

Draw back over the lines with a colored pencil so you don't miss transferring part of it. If you don't have graphite paper, turn over your drawing and draw with your soft pencil back over the lines. Turn it right side up; place it on the drawing paper and trace back over the lines with a colored pencil. You will have a nice, clean drawing to finish.

FINISHING

To make things easier to see and follow in the book, you can use drawing pens for the final step. Below are examples of strokes you can use if you want to finish your drawing and some tricks for making your drawings look dimensional. You can stop at Step 3 of each lesson and color your drawing, if you wish, by following the color instructions for each dog. You can use crayons, colored pencils, or markers. If you use markers, color the drawing first. Then finish by drawing the lines over the color with your drawing pen. You will love the results!

You will be learning how to draw dogs in this book. Most of the dogs are pets of people I know, including my own mutt, Casey. You can change the names to your own dog's name and make it look like your dog. Have fun learning how to draw dogs!

Practice laying down tone with your art pen by tracing around a popsicle stick to make a tone chart. 0% is white paper and 100% is solid black. For crosshatching, use thin, parallel lines that overlap as the tone gets darker:

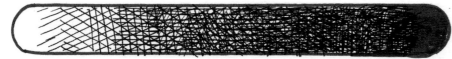

For stippling, use the very tip of the pen to make tiny dots. Don't bang the pen hard on the paper; use a light touch to keep the dots round. Use fewer dots farther apart for lighter areas and heavier dots closer together for dark areas.
Warning: Stippling takes a long time but is worth the effort!

Now try to make the same shape look dimensional with your strokes:

Akita - "Louis"

Akitas were bred in Japan to help their masters hunt wild boar and bears. Akitas are large, furry dogs that look like wolves with tails that curl up over their backs.

1. Begin with a large oval. Pay attention to the shape. Notice how and where the other shapes fit on and in the main shape. A large circle starts the tail.

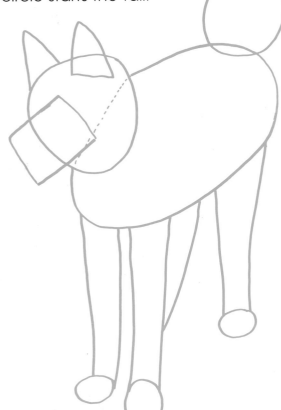

2. Connect the shapes to form a simple outline. Erase the areas where the shapes overlap, and any lines you don't need. Draw the legs up into the body. Notice the sideways question mark shape that will make the tail look curly. Pay attention to the placement of the eyes.

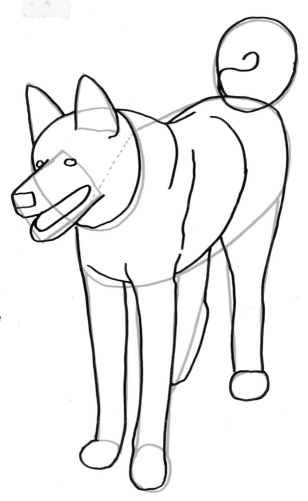

3. Detail the face and refine the outline. Pay close attention to the shapes that make the mouth look open. Indicate the areas where the tone will change dark-to-white on the legs, face, and body. Draw the collar and tag. If you want to color Louis, stop drawing at this point and switch to your colors.

For Color: Akitas can be tan and white, black and white, or brindled, like Louis.

4. To finish the drawing, use short, thin strokes to make the fur. Pay attention to the direction the fur grows, especially on the tail to indicate the curl. Watch the outside margins—keep them light! Lighter, thinner, and fewer strokes or stippling in the white parts will indicate tone.

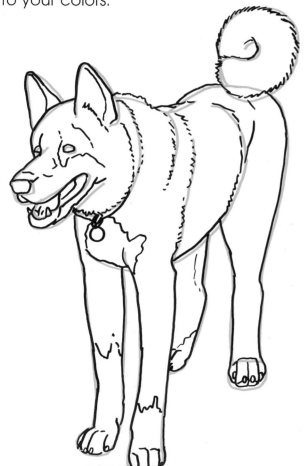

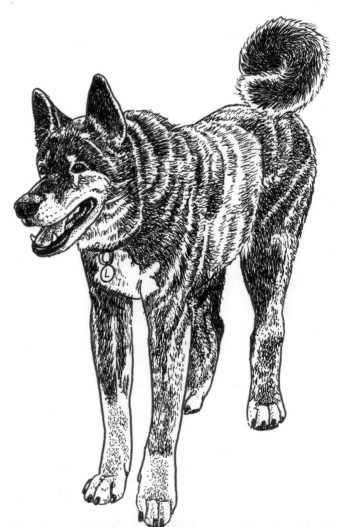

Beagle - "Bailey"

Beagles are small hounds bred for hunting small game, like rabbits. Known for their distinctive bark, Beagles make great, loyal pets.

1. Begin with an egg shape tilted to the right. Notice how and where the other shapes fit on and into the main shape.

2. Connect the shapes to form a simple outline. Erase the areas where the shapes overlap, and any lines you don't need. Add the shapes for the other back leg. Add the eye (notice the placement!) and the line of the mouth.

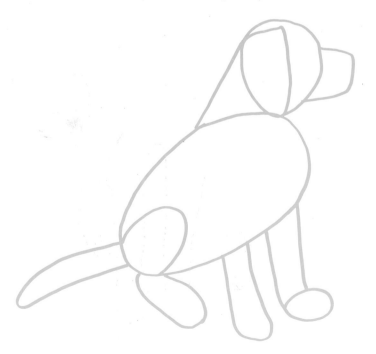

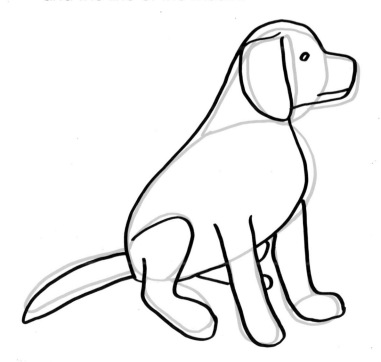

3. Detail the face and refine the outline. Notice the triangular shape of the eye and shape of the nose. Draw the feet and toes. Indicate the areas where the tone will change dark-to-white on the legs and body. If you want to color Bailey, stop drawing at this point and switch to your colors. You can also color with your markers at this point and use the black lines in Step 4 over the markers.

> **For Color:** Beagles are tan and white, with black on their backs and the base of the tail.

4. To finish the drawing, use short, thin strokes to make the fur, paying attention to the direction the fur grows. Leave the outer edges of the ears light or they'll blend into the body. Use heavier strokes for the darker areas and lighter, thinner strokes for the medium tones. Stipple in light tone in the white areas.

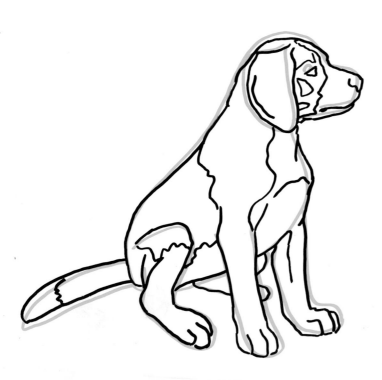

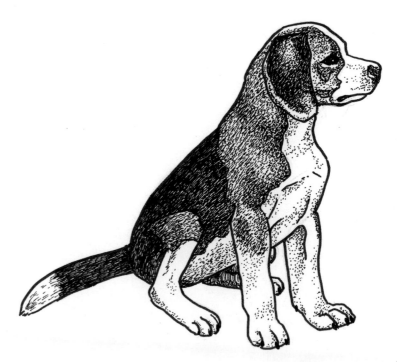

Rottweiler - "Bella"

"Rotties" were bred as cattle herders and guard dogs in Germany.
A large breed, Rottweilers make great family pets.

1. Begin with a long oval tipped up to the right. Notice how and where the other shapes fit on and in the main shape. The round head shape is inset right of the left edge of the main oval. Notice the shape of the lower (dog's left) front leg is shorter than the top (right).

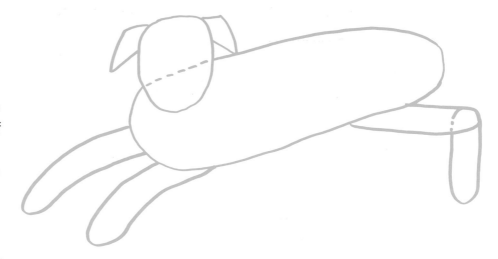

2. Connect the shapes to form a simple outline. Erase the areas where the shapes overlap, and any lines you don't need. Draw in the back leg under the body and the facial features. Notice the stumpy little tail!

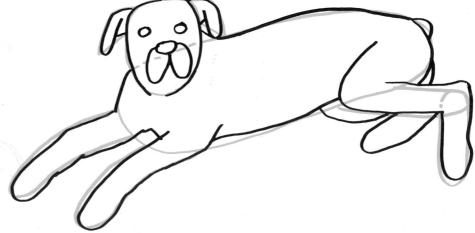

3. Detail the face and refine the outline. Detail the folds in the ears, the toes, and the pads on the back foot. Draw the areas where the tone will change black-to-reddish on the legs. If you want to color Bella, stop drawing at this point and switch to your colors.

For Color: Rottweilers are pitch-black with reddish markings on the face, eyebrows, feet, legs, neck, and chest.

Note: When drawing any solid black animal, make sure to leave the areas of highlight or you'll end up with a flat, black blob.

4. To finish the drawing, use very short, thin strokes to make the fur, paying attention to the direction the fur grows and to the highlight areas. Use the same stroke in the dark areas as in the light ones. Just use more strokes closer together to make the fur look realistic.

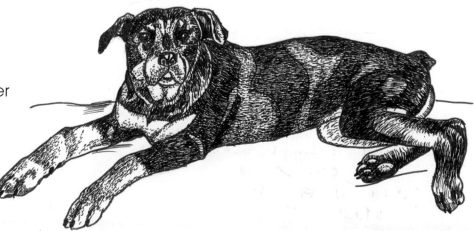

Dachshund - "George"

Dachshunds were bred in Europe to hunt badgers. Their long, thin shape and their passion for digging made them perfect for digging into badger burrows.

1. Begin with a long, thick "hot dog" shape. Notice how and where the other shapes fit on and in the main shape. Use triangles for the head, ears, and tops of legs. Use ovals for the feet.

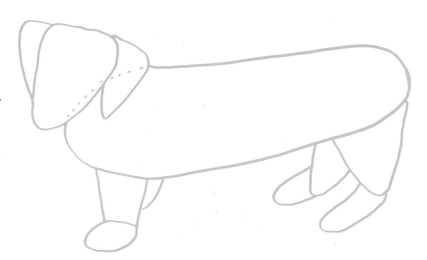

> **For Color:** Dachshunds can be tan and white, black and tan, or brindled, or red and white, like George. They also come in smooth, wire-haired, and long-haired varieties.

2. Connect the shapes to form a simple outline. Erase the areas where the shapes overlap, and any lines you don't need. Notice the eye on the left is higher than the eye on the right! Place the eyes and nose. Shape the ears. Draw the front legs up into the body. Add the long, thin tail.

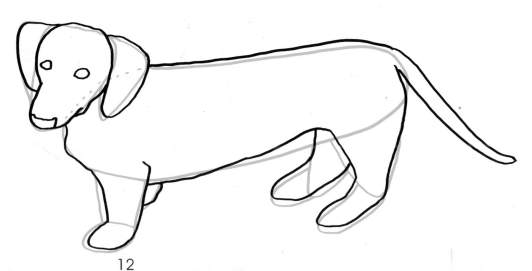

12

3. Detail the face and toes and then refine the outline. Indicate the areas where the tone gets lighter. If you want to color George, stop drawing at this point and switch to your colors.

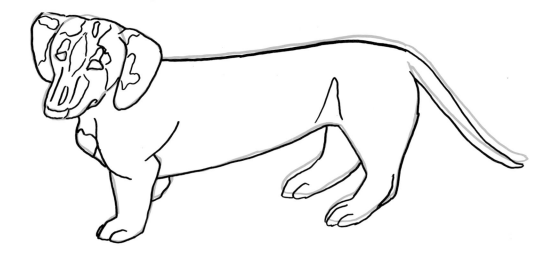

4. To finish the drawing, use short to medium length strokes to make the fur, paying attention to the direction the fur grows. Stipple in the areas of tone on the face where the fur is really short. Don't forget the toenails!

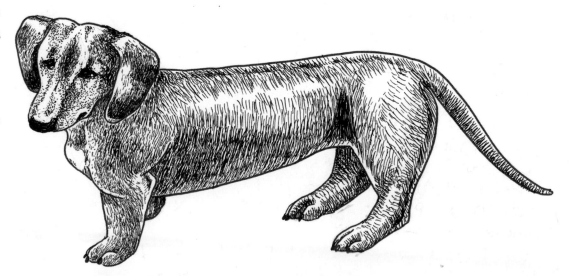

Dalmatian - "Jesse"

**Dalmatians were bred centuries ago in Eastern Europe.
They have been kept for a variety of purposes, but are best known in the United States
as firehouse dogs, taking their place with the firefighters on the big red trucks.**

1. Begin with a "potato" shape for the body, as shown. Notice how and where the other shapes fit on and in the main shape. Use rounded triangles for the head and ears. Use ovals for the feet.

2. Connect the shapes to form a simple outline. Erase the areas where the shapes overlap, and any lines you don't need. Add the line of the muzzle (nose) and the eyes. Notice how the left side of the nose lines up with the outside line of the face. Place the nose. Shape the ears. Draw the front legs up into the body.

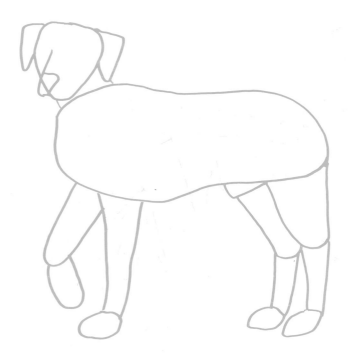

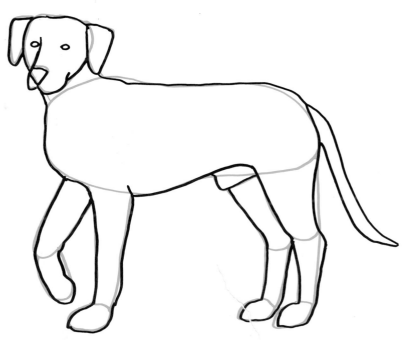

3. Detail the face and toes and then refine the outline. Indicate the muscles. If you want to color Jesse, stop drawing at this point and switch to your colors, although color will be limited to a little bit of shading.

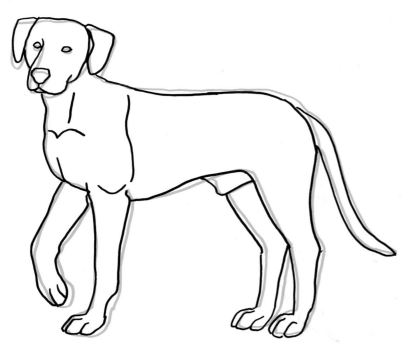

4. To finish the drawing, leave most of the body white. Spots are irregular and large—not little—round polka dots. Use short to medium length strokes to indicate the shading. No two Dalmatians are alike, so you can't do it wrong!

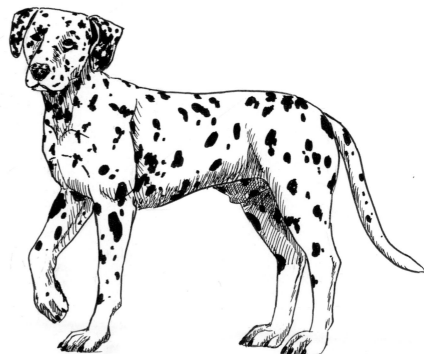

15

German Shepherd - "Cootie"

**Also known as Police Dogs, German Shepherds are one of the best-known breeds.
In addition to being loyal family pets, German Shepherds are among the leading breeds
for search and rescue, tracking, and bomb detection for police work.**

1. Cootie is lying down facing us, so begin with overlapping, free-form circles for the body. Notice how and where the other shapes fit on and in the main shape. Use rounded triangles for the head and ears. Use long ovals for the legs and tail. Notice how short the front leg shapes are. They're coming straight toward you, and the process of drawing them so they look right is called "foreshortening."

2. Connect the shapes to form a simple outline. Erase the areas where the shapes overlap, and any lines you don't need. Place the eyes, nose, and tongue. Shape the ears. Draw the front legs up into the body. Add the long, rounded tail.

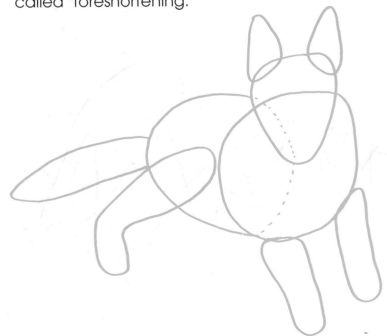

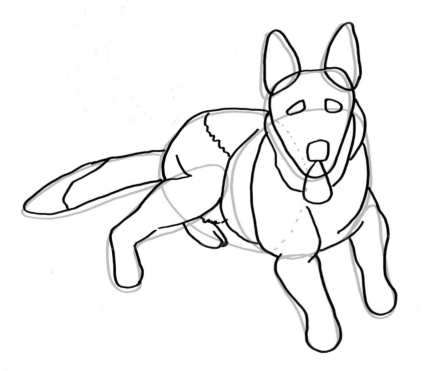

3. Detail the face and toes and then refine the outline. Draw in some light lines where the tone will change on the face and chest. Draw in the tennis ball (or other toy, if you like)! If you want to color Cootie, stop drawing at this point and switch to your colors.

For Color: German Shepherds are tan with a black muzzle, ears, and saddle. They can also be solid dark brown to black.

4. To finish the drawing, start with the face. Pay special attention to leaving the white spaces. Start with the dark patterns, then add tone to the lighter areas, and leave the very white areas alone! Stipple in the detail on the tongue.

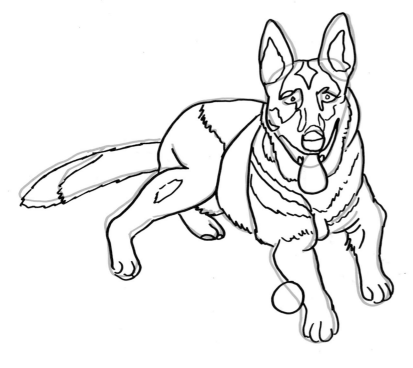

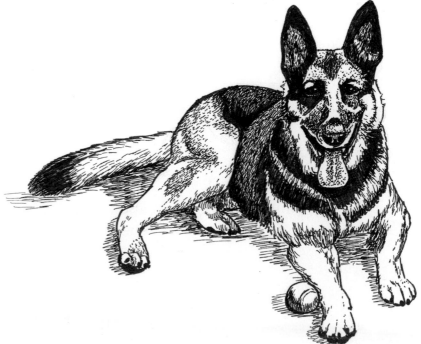

Golden Retriever - "Pluto"

"Goldens" were bred in Scotland with thick coats to keep them warm when retrieving game from cold lakes. Goldens love water and working with their masters in the field, but they also love being the playful clown of the family.

1. You'll be doing a portrait of Pluto, which means just his top half, focusing on his face. Begin with overlapping ovals and circles. Notice that the placement of the ovals for the ears starts halfway up the large main circle. The eyes line up with the top of the ears and the nose lines up halfway down the ears.

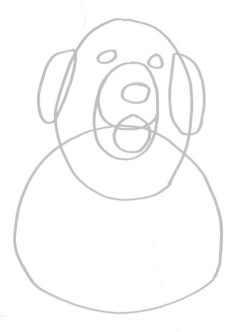

2. Connect the shapes to form a simple outline. Erase the areas where the shapes overlap, and any lines you don't need. Refine the eyes, nose, and tongue. Shape the ears and add the collar. Leave some of the edges loose and furry.

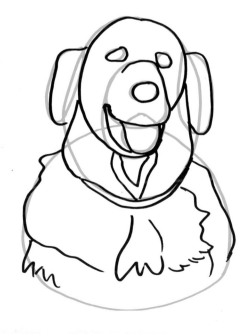

3. Detail the face and add the margins where the tone will change. If you want to color Pluto, stop drawing at this point and switch to your colors.

For Color: Golden Retrievers can vary from light to reddish golden. As they get older, they develop a white mask (face).

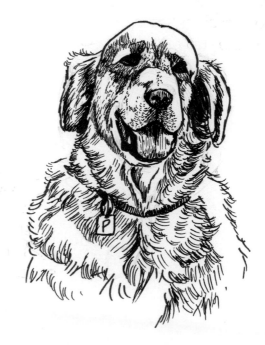

4. To finish the drawing, start with the dark patterns. Then add tone to the lighter areas and leave the very white areas alone! Use long, loose, curving strokes for the light fur and shorter strokes for the darker areas. Make sure you leave some lighter tone on the nose. If you're drawing your own Golden, make sure you put its initial on the tag.

Labrador Retriever "Shadow"

"Labs" are a North American species from Labrador, Newfoundland, Canada. They were bred to retrieve game from water. Among the most loved species, Labs are bred in three colors and make wonderful pets.

1. Shadow, a black Lab, is sleeping in rays of sunlight on the couch. Begin with overlapping free-form ovals. Notice that the placement of the ear starts halfway up the large main circle. The eyes line up with the top of the ears and the nose lines up halfway down the ears.

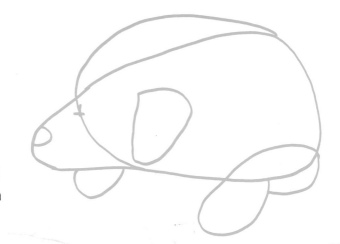

2. Connect the shapes to form a simple outline. Erase the areas where the shapes overlap, and any lines you don't need. Indicate the nose, ear, and eye, noticing where the eye lines up. Draw in the collar.

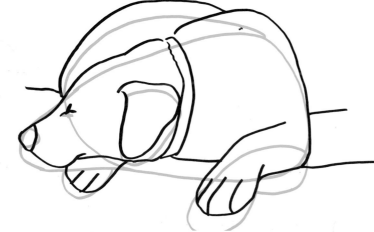

20

3. Detail the face and add all the margins where the tones will change. The pattern is very important! It's a "map" of where to add tone and where to leave white paper.

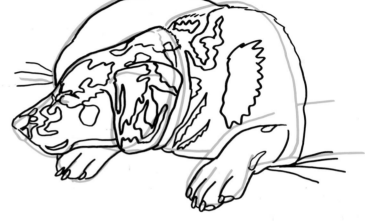

For Color: This is a drawing that is best left black and white, but if you want color, you can make your Lab chocolate brown or golden yellow instead of black.

4. The idea of this drawing is light on black to make it look realistic. To finish the drawing, start with the dark patterns. Then add tone to the lighter areas and leave the very white areas alone! Make sure that, where two areas of dark come close together, you leave a light margin so you don't end up with a black blob. The darkest areas can be colored in solid with a wide-tipped marker.

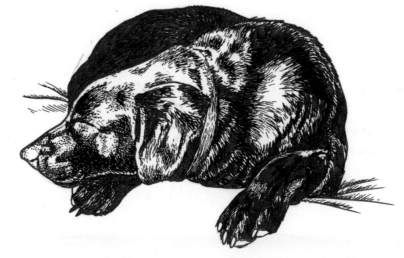

Chihuahua - "Cocoa"

Chihuahuas are among the smallest of dog species. When they're born, pups can fit in a teacup! Chihuahuas come from Central America and Mexico.

1. Begin with a rounded rectangle shape, with a triangle for the head in the upper left corner. Notice how and where the other shapes fit on and in the main shape. Use triangles for the ears, long triangles for the legs, ovals for the feet, and a half-circle for the curly tail.

2. Connect the shapes to form a simple outline. Erase the areas where the shapes overlap, and any lines you don't need. Add the eyes and nose. Shape the ears. Notice how the left eye is higher than the right and is on the same angle as the ears. Draw the legs up into the body. Add the inside line for the curl in the tail.

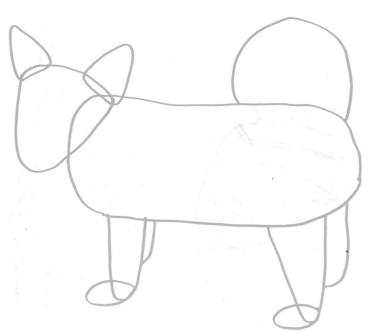

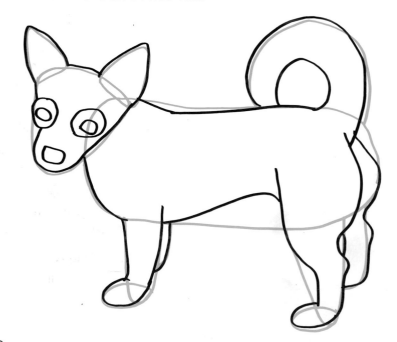

3. Detail the eyes, ears, toes, and refine the outline. Fuzz the back of the tail and haunches and indicate the lighter areas of tone. If you want to color Cocoa, stop drawing at this point and switch to your colors.

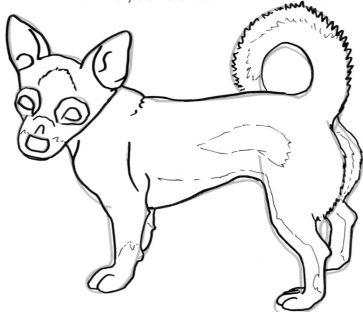

For Color: Chihuahuas can be almost any color, from tan and white to black. Cocoa, of course, is cocoa and white!

Tip: If you're having trouble figuring out what's wrong with your drawing, walk away from it and come back to it or hold it up to a mirror. The mistakes will jump out at you!

4. To finish the drawing, detail the eyes and nose and leave a sparkle in the eyes. Use short strokes to make the fur, paying attention to the direction the fur grows. Don't forget the toenails!

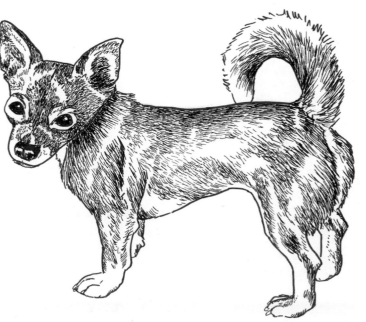

Mixed Breed (Mutt) - "Casey"

Mutts are the best dogs! Of no particular bloodline, they are loyal, loving members of the family. Casey has been part of the author's family for 13 years.

1. Begin with an oval for the body and a circle for the head. A rectangle forms the muzzle and a triangle forms the ear. Long "hot dog" shapes form the legs, and a circle forms the haunch. Place the eye at the upper right corner of the muzzle.

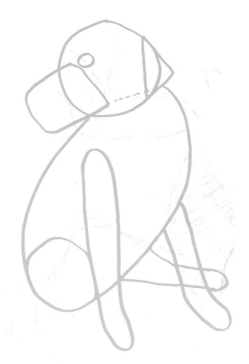

2. Connect the shapes to form a simple outline. Erase the areas where the shapes overlap, and any lines you don't need. Add the nose and shape the ear. Draw the front leg up into the body and draw in the far back leg. Draw the tone shapes around the eye. Add the tongue.

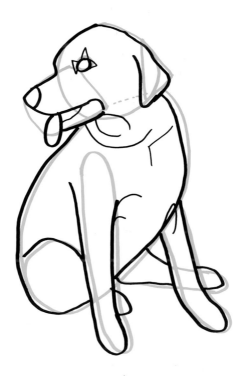

3. Detail the eye, ear, and toes and then refine the outline. Shape the legs and add the tip of the tail. Indicate the lighter areas of tone and the muscles. If you want to color Casey, stop drawing at this point and switch to your colors.

4. To finish the drawing, detail the eyes and nose and leave a sparkle in the eye. Use short strokes to make the fur, paying attention to the direction the fur grows. Use more strokes closer together where the fur is darker; less and farther apart where it's light. Leave the white parts. Don't forget the toenails!

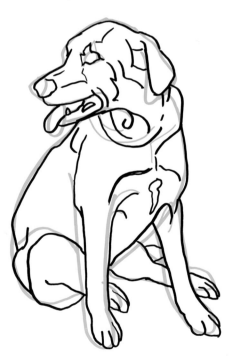

For Color: Mutts can be any size, shape, or color! Casey is tan with a black saddle and white markings on her chest.

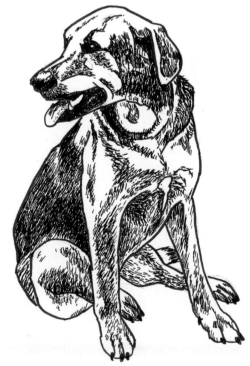

Great Dane - "Bess"

Great Danes are among the largest of dog breeds. They were bred in Germany to hunt wild boar.

1. Begin with an oval for the body and a circle for the head, leaving a finger's width of space in between. Connect the head to the body with two lines to form the neck. A rectangle forms the muzzle and long, pointy triangles form the ears. Long "hot dog" shapes form the legs and an oval forms the haunch. Long ovals form the lower back legs.

2. Connect the shapes to form a simple outline. Erase the areas where the shapes overlap, and any lines you don't need. Add the nose and eyes and then shape the ears. Draw the front leg up into the body and shape the back legs. Add the long, pointy tail.

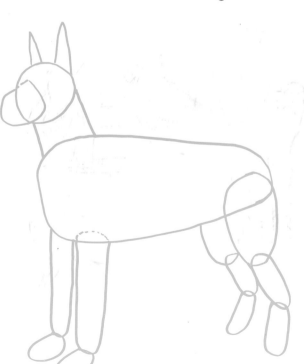

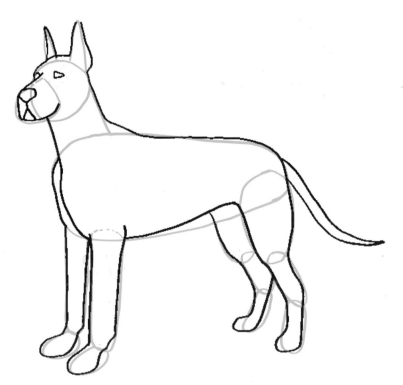

3. Detail the eye, ear, and toes and then refine the outline. Refine the legs and add the toes. Indicate the muscles and areas of tone. If you want to color Bess, stop drawing at this point and switch to your colors.

4. To finish the drawing, detail the eyes and nose and leave a sparkle in the eye. Use short strokes to make the fur, paying attention to the direction the fur grows. Use more strokes closer together on the muzzle and fewer strokes for the lighter tones. Leave the white parts white.

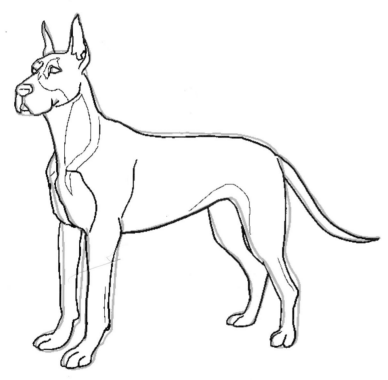

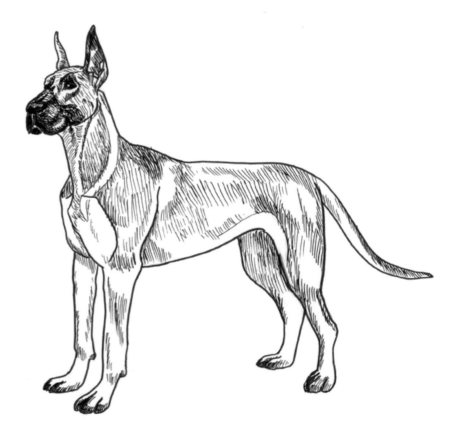

For Color: Great Danes can be any color from solid black to piebald (black and white like a pinto) to tan and white, like Bess.

Jack Russell Terrier "M. C."

Jack Russells were bred to hunt and kill rats in burrows. Their tails are cropped so their owners can pull them back out of the burrows when they have done their jobs! They are all muscle and energy.

1. Begin with an egg-shaped oval for the body. Insert a smaller egg shape for the chest. Use rounded triangles for the head and ears. The tail is a half oval. Long "hot dog" shapes form the front legs. The back leg is created from ovals of various shapes.

2. Connect the shapes to form a simple outline. Erase the areas where the shapes overlap, and any lines you don't need. Draw up into the main oval to shape the body and refine the legs. Note the position of the eyes and nose. Draw in the far back leg and the collar.

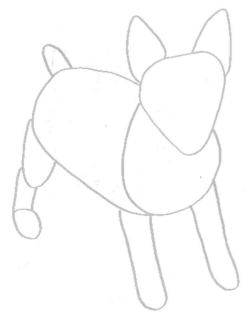

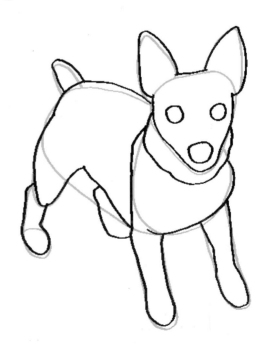

3. Detail the eyes, ears, and toes, refining the areas of tone changes. Refine the legs and add the toes. If you want to color M. C., stop drawing at this point and switch to your colors.

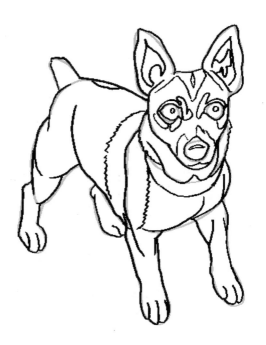

For Color: Jack Russells can vary in color, but are mostly white with patches of brown to black. They are bred in varieties that can include whiskers on the face around the nose.

4. To finish the drawing, detail the eyes and nose and leave a sparkle in the eye. Use tiny strokes to create the fur, paying attention to the direction the fur grows, and stipple in detail where the fur is very short. Leave the white parts white and pay special attention to the areas where the tones define the muscles, such as the chest and back leg. Give M. C. her initials on her tag or name her yourself!

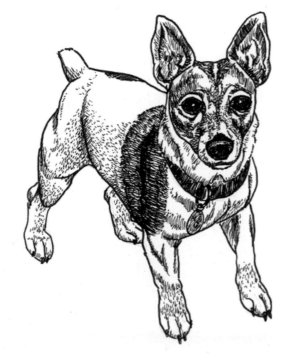

ABOUT THE ARTIST

Robin Lee Makowski is a professional artist, illustrator, and instructor. She specializes in watercolor painting and drawing and has illustrated more than thirty children's books.

"I always loved science and nature," explains the artist. "I studied everything closely and tried to draw it. I noticed the way things lined up, how close or far away things were, the way the light hit them, and how the light affected the color."

"It's so important to learn how to draw," she insists. "You have to realize that when you can draw, you're free. All you need is a pencil and paper and you can create wherever you are. Drawing is rewarding both in the process and the product."

Robin lives in Hobe Sound, Florida, with her husband, two sons, and her best friend, her mutt Casey.

Visit Robin at her website: www.rlmart.com

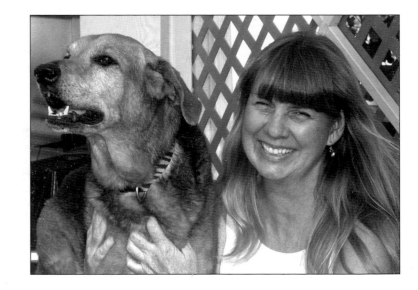